Restricted Movement

Poems by Traci O'Dea

Paintings by Tommy O'Dea

Scotland Street Press
EDINBURGH

First Published in the UK in 2021 by

Scotland Street Press

100 Willowbrae Avenue

Edinburgh EH8 7HU

A CIP record for this book is available from the British Library.

ISBN 978-1-910895-528

Typeset and cover design by Antonia Weir in Edinburgh

Cover image and all paintings by Tommy O'Dea

Scotland Street Press wishes to thank Creative Scotland for their support during the pandemic.

This publication is supported by:

For Patricia Lynn

Artworks

Artworks listed in order of appearance:

Stardust, acrylic paint, glue, glitter, ballpoint pen. ND.

Jellybelly, acrylic paint, glitter, glue. ND

Untitled, acrylic paint, pencil. ND.

Fells Point Fishbone, acrylic paint, glitter. 2010.

Monkeyfish, acrylic paint, glitter, glue. 2009.

Silver Pineapple, glitter, glue, acrylic paint, highlighter. 2004.

Stig of the Dump, acrylic paint, marker, found object. 2016.

Pot Connect, glitter, glue, marker, acrylic paint, string, herbs. 2004.

Atomic Balls, glitter, marker, acrylic paint. 2002.

Red Pineapple, acrylic paint. 2014.

Flowers of Isolation I, acrylic paint. 2020.

Flowers of Isolation II, acrylic paint. 2020.

Blue Lady, glue, acrylic paint, melted crayon. ND.

Jelly Nuclei, found object, glitter, glue, paint, highlighter. 2003.

Rose in Spanish Harlem, glue and acrylic paint. 2004.

Starfish, glue, glitter, acrylic paint. ND.

Sailor's Delight, melted crayon, pencil, sea glass from New Zealand. ND.

Jelly Longlegs, acrylic paint, glitter, glue, highlighter. 2014.

Canned Sun, acrylic paint, glitter glue. 2002.

Untitled, toothpicks, wax, acrylic paint.2003.

Untitled, acrylic paint, glitter, crayon. ND.

Gold Heart, glue and acylic paint. 2014.

Baltimore Harbour, found objects, acrylic paint. ND.

Legless, epoxy, acrylic paint, aquarium stones. ND.

Contents

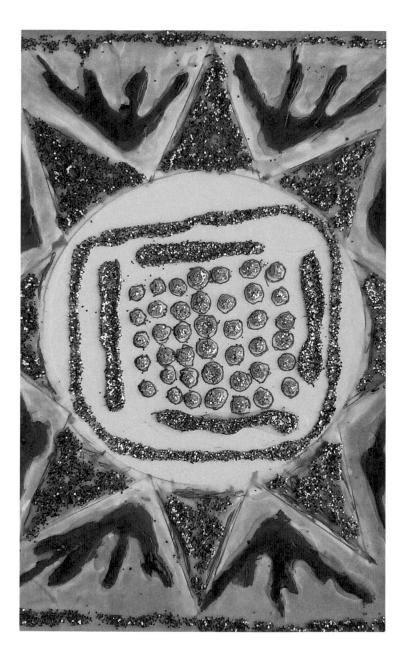

Restricted Movement

'All persons living in the State of Maryland are hereby ordered, effective as of 8:00 p.m. on March 30, 2020, to stay in their homes or places of residence'

–Order of the Governor of the State of Maryland Number 20-03-30-01

No order tells my dad what he can't do.
You'd think he'd be the one most used to it,
but prison didn't break him, only made
him value freedom more. He disappears
for days, to prove the laws do not apply
to him. Each time, my heart sours, afizz
like blue-green algae film on stagnant pond.

Neighbours ask if he's okay. 'He's fine,'
I lie, or maybe it's a prayer. I try
to recollect what it was like before,
what I worried about. Earlier still,
my whole childhood he spent in jail. I slept
just fine back then. I never dreamt of him.
You'd think I'd be the one most used to it.

Two Hours of Exercise

'...all Islanders will still be able to leave their homes for a maximum of two hours...for daily exercise.'

–Jersey Deputy Richard Renouf

I.

I try jogging. After two days, I wake
with a slipped disc so trade in running shoes
for Wellingtons and plan my exercise
around each day's low tide when I explore
rock pools—inverse pyramids cut deep
in tongue-pink stone by water's edge, awash
with sprays of pepper dulse, transparent prawns
on ribbon sea kelp stalks, beadlet anemones,
and limpets with shells like nazar amulets,
you know the ones, to ward off evil eye.
My husband comes with me one day but he
prefers the sandy swathes between the rocks.

II.

A black and zebra halter bathing suit,
red paisley robe, gold sandals on my feet,
I flip-flop down to the sea pool. Two cops
survey the crowd, ensure that everyone
is there for exercise, the only time
we islanders can go outside. I wade

in up to my ankles. My toes go numb.
I hear a woman slur to the police,
'I just took off my bra and shoes to swim.'
A shopping bag of beer beside her stuff.
I check to see if anyone's observed
me not get in. The few nearby don't care.
Police are too occupied to notice me.
I tiptoe through the seaweed to my towel
and spot a shard of green sea glass. I pocket
it for dad, thumb-rub its rough texture
as I ascend the slip and head back home.

III.

In roller skates, I crabwalk sideways down
carpeted stairs to our front door, don't push
the button to cross the street because no cars.
Acrylic wheels on wood as I roll the pier.
The gaps between the planks perplex ankles
that learned to glide on Skateland's gloss, school gyms
and sleepover cement basements. I'd loop
for hours on my own, singing along
to words of songs I didn't understand
from El DeBarge, The Go-Go's, Fleetwood Mac.
Like Dad, my husband's never seen me skate.
He's so surprised when I can do a thing.

IV.

Surface units enlarge: sand to pebbles,
stones to rocks to boulders, granite island.
I scurry over them—a hermit crab—
but feel as graceful as a member of
the yamakasi group. My eyes and feet
bypass my percolating brain. Each leap
occurs before I have the chance to think.
If only he could see me now. I slip,
step wrong; the boulders wobble under me.

Triolet

'Marylanders who see unlawful behavior are encouraged to report it.'

–The Office of Governor Larry Hogan

No one has heard from him in weeks. I'm sure
that's not quite true. Strangers have seen him, talked
to him on corners or some liquor store
no one has heard of. Then, in weeks, I'm sure
he'll appear, cracking jokes like before.
Or he might be dead. His body lined in chalk
no one has stirred for some weeks. I assure
you that's not right, strangers. You've seen him. Talk.

First Month of Quarantine

My days are filled with watching Jersey's tides,
reading, baking, writing, not calling Dad.
He's turned up in a Florida rehab
and doesn't really know what's going on,
believes, at thirty days, he'll be released
to his apartment back in Baltimore—
rooms in a house I cleared a year ago
after his landlord called: Dad wasn't safe.
He fell. He broke his eye socket, left on
the stove for days. Blood stains. One time he used
Black Flag bug killer for cooking spray.
Forgot about money he spent and claims
we steal from him. I do, but not his cash.
As I packed up his photographs and art,
I came across his drawing diary
my sister gave him several years ago.
I brought it home and keep it by my bed
to visit his most private thoughts: headlines
he's copied down, some smut, his football bets,
a pencil drawing of a fishwoman
with just one breast, metallic pen inkblots,
his memories of Mom and how they met,
his diagnosis, a Valentine to me.
I'll filch his words and write new poetry:

Found Poem: First Kiss

(stolen snippets translated from Dad's drawing diary)

Against my canoe, the water snaps—a cap
gun going off. A backpack weighs me down.
Trace it. A dead end or a cul de sac.
Five months and counting. Soon you'll feel like you're
inside a microwave. Then you'll be freezing.
Summer's gone too soon, Frog Mortar Creek
will soon be solid ice. 'Mimi, Noot Noot',
the mother calls to the boy and his sister.
She's flipping pancakes. Watching the butter melt,
crawling on the floor, the boy will wait
until the creek freezes over to see the girl.
Please mind the gap, my mind is reeling like
a whirligig; my tongue is tied in knots.
You feel like an intruder. The sun is up.
Camaros, Mustangs race to the red light.
After driving a half-hour journey in
a baby blue 1961
Dodge Rambler while polishing off half a pint
of blackberry brandy, Mr. Boston
arrives at 123 Hughes Shore Road
at 6:15pm. The instructions were:
call first. 'Hello, is the ice frozen yet?'
Skating about one hour, I noticed she
was chewing gum and asked for some, she said,
'It's all I have' and showed it between her teeth.

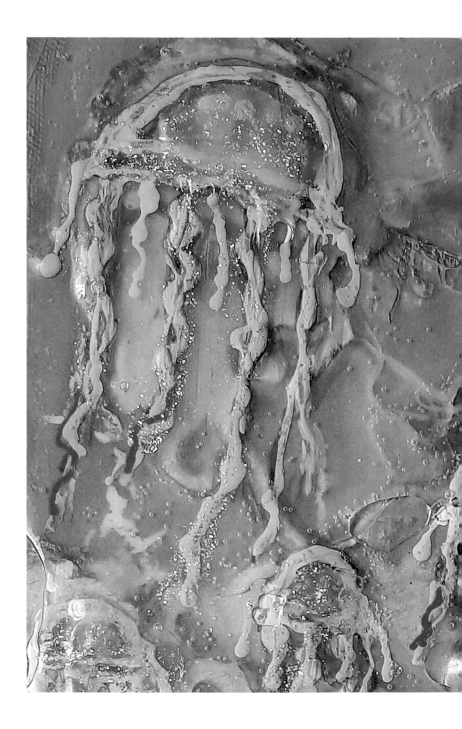

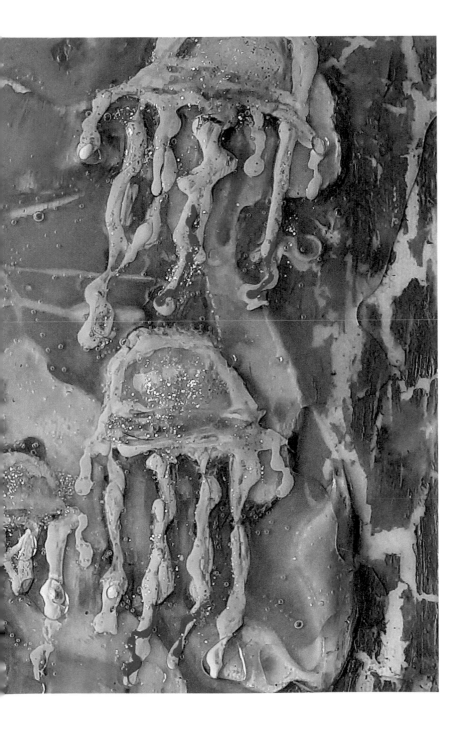

Dear Dad,

Rehab released you and put you on a plane to Baltimore.
During lockdown. You lied; said you could stay at Uncle Kenny's house.
You've no concept that everything is closed. That Uncle Kenny is at risk.
His wife more so. You turned up at his door, despite him saying no.
He let you sleep one night then drove you to the train.
That was four days ago. I wonder if you'll show up dead? In jail?

I get the call. You're in ER after an overdose, awake, and in a private room.
We talk each day for three days straight. Three days of normalcy,
of chats about my poetry and getting you to paint again. Reminding you
that I have all your things (not mentioning your drawing diary.)
We set up a new place for you. A group home in Reisterstown.
You say it sounds okay. The social worker orders a taxi to take you there,
but you never show, so you're missing again.

A week later. I'm numb. No word from you. In hospital, at least
you have a phone. You've 'lost' more mobile phones than I can count.
I don't want to write. I want to drink. Bobby gets annoyed with me
because I won't reveal the secret ingredient in my eggplant parm
(it's powdered almonds). While I'm layering the pan, I get a text
from your friend Donna. 'He's at Bayview...I gave consent to treat
him but I'd really like to know what I'm consenting them
to treat him for...' You've probably OD'd again, I think. I spoon
ricotta cheese on top of eggplant strips. My phone vibrates.
Donna is calling now. I guess that you are dead. Her voice
sounds scratchy as she recounts that you were found non-responsive in
a hotel room with alcohol and drugs. You've been injected with Narcan—
'an opioid antagonist' I learn—but haven't woken up;

they've given you a breathing tube. She says to call
the doctor back at four pm your time to get the test results,
find out what's next. The red sauce spreads
thicker than blood. Hands softclaw at my throat.
I want to push it all away, watch Awkafina clips until I fall asleep.
I check the eggplant in the oven, pour myself a rum
despite the pledge I wouldn't drink this week. My heart's
a tomato pressing through a ricer. Juice forces through
the holes, but in the metal trap is desiccated pulp.

Coming Around

At 6am, day 41 of Covid
quarantine, I wake up weak, fatigued.
The sound of high-tide waves lapping sea wall.
A cackle echoes up from where? I think
the street. Instead, I see a group of six
bobbing and gossiping (six feet apart)
in the sea pool. I envy them, then do
something I never do unless I'm ill—
fall back asleep.
 Three orcas in a blue
canal beneath a bridge in Florida.
I tumble in. Current sweeps me to them,
but I'm not scared. They nudge my floating form,
lift me. I'm flat on my shirtless back, face up,
my cheek to dorsal fin. Against the touch-
starved surface of my neck, their skin feels like
cat tongue. I stir then reach across the bed
and fade again.
 A long-forgotten crush
whose hands have featured in my poetry.
We're stood; our wings and backs of heads connect;
we coo, adjust, shift weight. He bends his back,
I hunch. I stretch my arms out wide, he curls
into himself.
 Dreams give contact I crave:
an arm-in-arm stroll down a cobbled street,
damp wrists on shoulders at the sweaty club,
a kiss on cheek, or Dad holding my hand.

My Father's Self-Portrait

'He moves in darkness as it seems to me,
Not of woods only and the shade of trees.'
 –Robert Frost from 'Mending Wall'

This painting's granite grey and forest green,
but I can't picture him as mountains, trees—
he's sand and sea, like me.
 Last night I dreamt
we had dinner with Charles; she wondered why
my eyes are darkest brown and his pale blue.
I said he's bright and happy surface sea;
I'm silt-stirred depths.
 Yesterday afternoon,
a doctor called. A cleaner found him passed
out in a motel room, pneumonia in
both lungs and possibly Covid-19. She asked
at what point they should not resuscitate.
What does that even mean? Can doctors choose
to let you die? I told her, 'Do it all,'
unless he'll be brain dead. When he wakes up,
I'll ask. And what to do with his remains.
An urn? Or sprinkle them on Shakespeare Street
where he grew up?
 Like in my dream,
the painting's eyes appear washed out, obscured
by glue and canned paint overspray. Grey skin,
speckled and scratched, could be interpreted
as low-tide rocks but looks a lot like ash.

Dream Journal: Hung Up

I drop into a dumpster of wire hangers.
My ripple swells to the metal walls and bongs
like someone threw a brick against the side.
Wriggling makes me sink. Quicksand of rust.
Hooks snag forearms, encircle toes. My neck
is ringed. They creep and clamp my shoulders, wrists,
and waist. Short hair is plaited into them.
Through copper depths, I gasp for air through gaps.
Then I give in. The clanging becomes wind-
chimes underwater. The twisted metal tastes
like strands of stale black shoestring licorice.

Dream Journal: Rollercoaster

It clicks and grinds at first, then starts to move.
I clench my eyes and grip, hating to admit
I'm not in charge. All I can do is sit:
harnessed, strapped, and bolted to one groove
that governs where we go. There's one last snap,
a hush, and then the roar of the release.
Why in the hell did I choose to ride this trap?
I could've stayed behind and watched in peace
like you, down there, pretending life's complete
without the thrill, hoping I'll be tossed off track.
You'd love to see me crash into the line
below. After dropping more than sixty feet,
I laugh, knowing it's too late to turn back.
You hold your breath until my last decline.

Dream Journal: Waterscapes

I.
The thinnest glass I know,
a slide cover for microscopes,
is strong enough to flatten eye-dropped worlds,
worlds that are still deep
enough for what's inside
to swim around. I lower the lens
toward the pressed landscape
and chant, 'Restraint'.
Then just before I can observe a tiny heart
beating inside of each amoebic speck
that's backlit through the aperture,
when I'm one notch away,
the glass shatters
from the crush of the objective lens.
I've gone too far again.

II.
You walk by my station on your way out
and say, 'Happy Holidays.'
You're paused, and poised to part
until you extract from your jacket sleeve
a twig of mistletoe
and dangle it above our heads.
(It is, in fact, a wrinkled bank receipt,
but it still does the trick.)
You slide your hand past my open palm
and touch the thinnest skin I know,
over my wrist. I open my eyes and see
the silver backs of leaves
and know it means there's rain ahead,
high tide breaking over sea walls.
So much debris is left behind:
a stew of seaweed, cigarette filters,
polystyrene, fish bones,
whole worlds waiting
for a chance to be reclaimed.

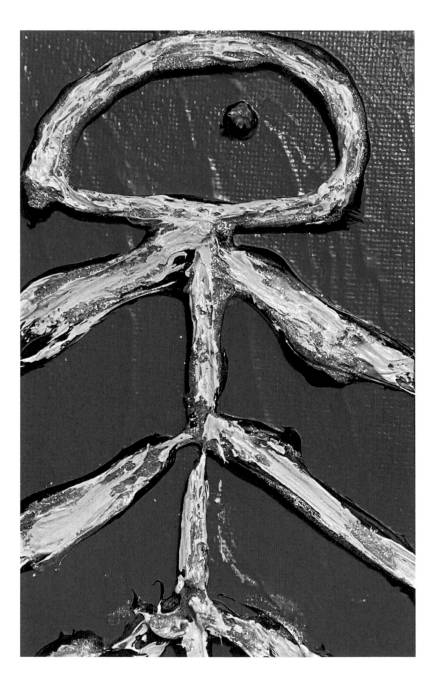

Dear Dad,

You've been admitted to the ICU. That's all we know. That you're
alive, hooked up to a machine that breathes for you.
A coma for three days. Each time I call, I fear the worst.

You wake. I speak to you. You've lost the word for castle.
I need to find you one—a fortress where you're safe from you.
Your credit cards, ID and clothes that had been with you
at discharge are all gone, too. Stolen, you say.

The hospital arranges physical therapy for your recovery
at a facility with a view of the sewage treatment plant
that looks like a Russian cathedral roof lopped off and transplanted
to Baltimore. You ride the 'eucalyptical machine' each day.
You'll be there at least six weeks. Time for us to find
a long-term residence. I email government agencies
to see if they can help. I Google 'geriatric substance abuse'
and read articles about its growing prevalence and the lack of care.
The only place I find with that specific offering
is a private rehab in the mountains that costs
$70,000 per week. And, no, they don't take Medicare.

No matter where you go, I'm grateful to the pandemic
because you can't have random visitors (aka drug dealers),
and you won't be free to roam. I secure a room
at an assisted living home not far from your old neighbourhood,
but closer to a Blue Light Zone. (The city installed the lights

and cameras to deter crime in certain parts of town,
but you always joked that they were advertisements—
'Need drugs? Drive to a Blue Light Zone!') *It's probably not*
an ideal spot for you, but they assure me residents are not allowed
to stray beyond the porch. The facility gives me a discharge date.
I book flights to take you there myself, so you don't disappear again.

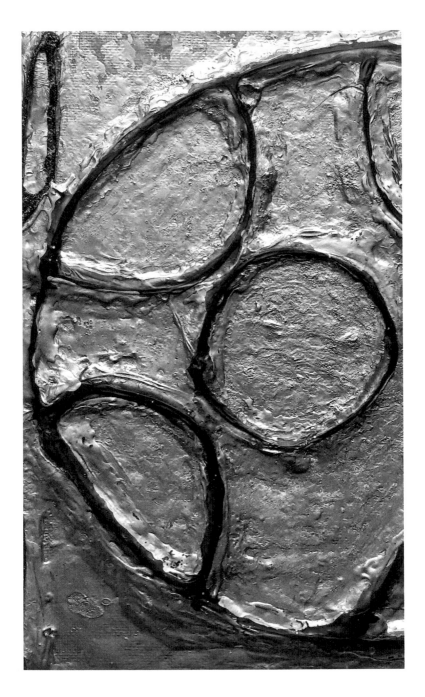

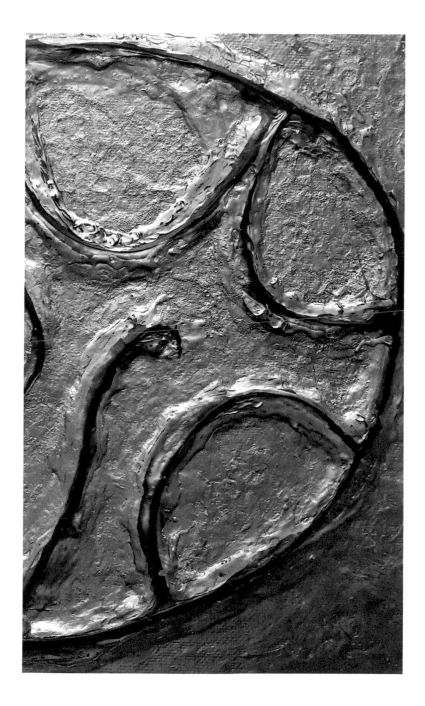

Tarot

Yvonne asks me to windscreen-wipe my mind
then concentrate on one question and pick
from her archangel deck. While shuffling them,
I ask if Dad will be okay then flip
The Piper card. A nude, wreathed warrior
kisses the measured reeds of a pan flute.
He's full of life, ablur and colourful
in two-dimensional, hand-sketched sepia.

I picture Dad, inert, sunken and grey
in a too-loose gown. Beside his bed, a heap
of broken bagpipe parts—his breathing tube
and lungs I must repair with silver tape,
waxed hemp and superglue, inflate with air,
play anything through them that's not a dirge.

Shakespeare Street

'The General Assembly shall enact no law authorizing private
property to be taken for public use without just compensation,
to be agreed upon between the parties or awarded by a jury,
being first paid or tendered to the party entitled to such
compensation...'

–Maryland Constitution, Article III, section 40B

Tommy O'Dea was born on Shakespeare Street,
a one-block road in Fells Point, Baltimore,
between Broadway and Bond. 500 feet
from the water taxi dock. First theft, first score,
first fight. When I called Uncle Kenny's house,
Aunt Wanda said, 'He's always had a good heart.'
Told me he shoveled sidewalks, swept the stoops
of all the houses on the street. 'They'd try
to pay him, but he wouldn't take a dime.'
He once told me how Babcia, who came to the States
from Poland in 1910, would grab his ears
and chase him with a broom, 'and cuss at me
and my friends for throwing snowballs at passing cars.'
His maternal granddad wrote the payroll checks
for the city snow plow crew, so they'd be sure
to clear one of the shortest, least-traveled roads—
Shakespeare Street—before anything else,

'or they wouldn't get paid,' Dad said with pride.
His aunt ran numbers for the neighbourhood—
a plywood wall with a thousand pigeon holes
from triple-o to nine-nine-nine. She'd fill
each cavity with bets. A number hit,
she'd pay; no number love, she kept the cash.
When he was a teenager, the city proclaimed
eminent domain and bought the block
of Shakespeare Street to build a new highway.
His family moved to Highlandtown. Since then,
he's been unmoored. The highway never came.
The houses on Shakespeare Street were auctioned off.

Airport Hotel

My mouth tastes like mulch. Eyes closed, I reach and find
the foil wrapper from the pillow mint
I ate last night after I crawled into bed half blind.

I suck on it. So now, it's mulch and metal with a hint
of After Eight. I bury my face in the mattress pad,
avoid my phone in case there's news of Dad.

Airsick, Flying Solo

Flying during the pandemic means no one's within ten rows of me.
My only company?
The disembodied arm of an action figure that is jammed
into the airplane windowsill. I feel ill. Seatbelt light be damned
as I can't handle it across my gut right now.
With my cotton sleeve, I blot my brow,
twist on the air, install
my cheek against the disinfected, dimpled wall.
I picture some kid wrenching out the manufactured
hero but leaving behind its limb, more than fractured.
Our captain mentions turbulence
that could keep up until we land. What prevents
me from using the paper bag that comes with every seat?
(I used it once before and swear that puking's never been so neat.
No one even knew that I'd been sick—
the process was not messy but almost polite and slick—
till Dad, my right-hand man, reached up to buzz
the flight attendant and ask her what it was
that we should do with the sack.) Behind the Sky Mall catalog, I finger
the wired bag but let it linger
in its spot. The sweats have passed. Canned
air blows my bangs out of place. I fix them as we start to land.

At Uncle Ricky's funeral, a great-aunt
we'd never met grabbed my sister by her chin but didn't plant
one on her cheek. Instead, inspected her profile long enough to say
'You're Tommy's girl.' Her eyes to me, then back to Sis, then walked away.
A shot in my wedding album shows
him in a sober pose,
forcing a smile next to me among the bustle of the cocktail hour
well-wishers, and I can hear the sour
mix breaking open ice cubes, my husband's voice nearby,
the camera shutter's sigh,
but on the facing page,
the dance floor's silent with Dad and Sis on it, band playing on the stage.
Eyes closed and jawbone pressed
against her temple, he holds her to his chest.
The photo doesn't show arm tracks from when he first relapsed.
She slipped the needle in his neck for him. (His other veins had all collapsed.)

Still queasy, after the Hoover
ear-pop descent, I grip the rubber rail of the people mover
in the under-construction arrivals hall, noticing that I'm ten feet beneath
the place an older escalator used to grind its teeth.
Its outline painted high up on the wall, inside a lighter shade
of green than what was sprayed
around it. A jagged hole at its base spews wires, torn up insulation,
like the bionic woman's shoulder socket after amputation.

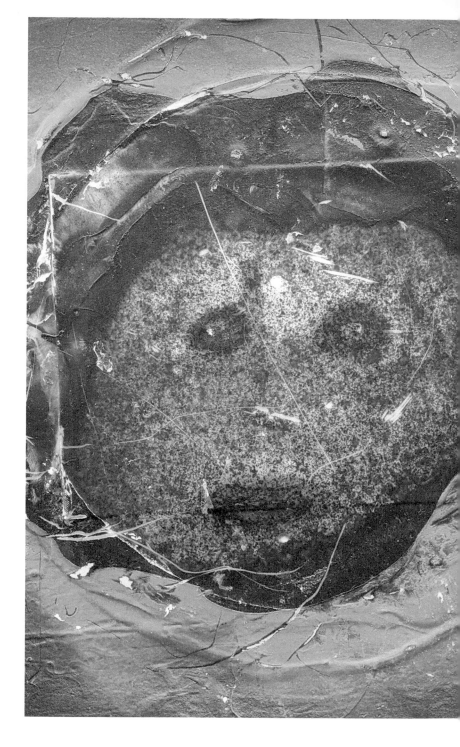

Dear Dad,

I pick you up at the physical therapy facility.
Creepy moustache. Jagged teeth. Too skinny
and shuffling. Like a junkie. (You are a junkie, I remind myself.)
You've lost the partial dentures you first got twenty years ago,
the aftermath of a heavy chain—the kind that straps
down crates on ships where you worked as a stevedore—
snapped free and whipped you in the jaw.
'Stop at the Royal Farm. I need coffee and cigarettes.'
'We're late.' 'I've been locked up for weeks.
I want a cigarette.' 'Maybe it's time for you to quit.'
'Don't start with me.' We stop, buy what you need,
I get you settled in the home. It's not a home.
We both know that. Next day, you request more cigarettes,
coffee, sugar, deodorant, some cargo shorts, a belt.
I can't go back because I'm meant to be in isolation
until my test results come in. I order you what you need. The home
calls back and says to send adult diapers as well.

I'm avoiding calling you again. This time, from Baltimore
where peaceful protesters are toppling statues, painting messages
on thoroughfares, and marching down York Road.
I feel more helpless only 20 miles away and quarantined at Mom's.
The assisted living isn't sure that they can handle you.
I understand, I say, but where are you supposed to go?
You'll end up on the streets which means the hospital or dead.
I hate writing this down because I'm living it,
but if I don't, it paralyses me.

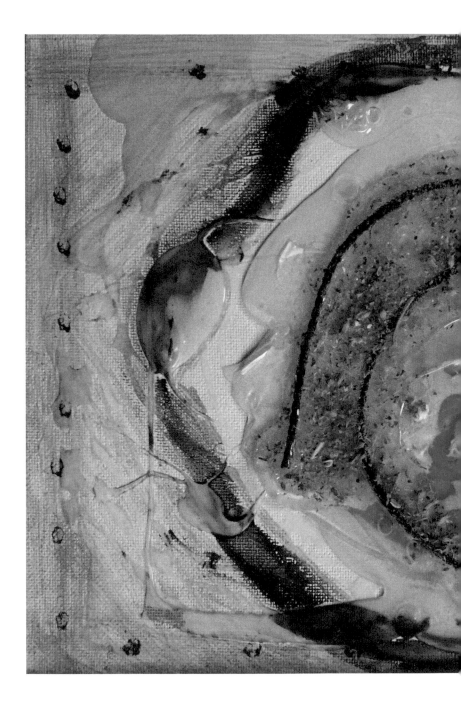

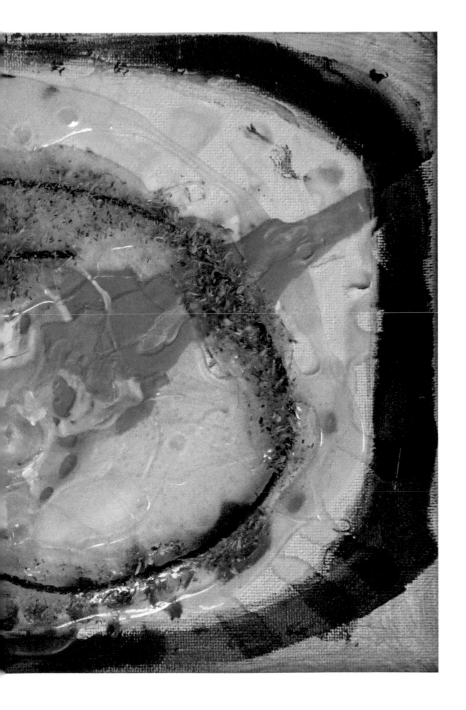

Testing

The closest mobile testing site is booked, so my appointment's 30 miles away, a week after I'm home. I drive Mom's car on roads I haven't been on since 2006, when I was adjunct faculty, remember once as I was walking by the campus gurgling goldfish pond, I spied a mallard I believed was stuffed until it shook. I wanted Dad to see it through the phone: green feathers shone like broken Christmas balls beneath the tree or shamrock garland on the street after the St. Patrick's Day Parade when Mayor O'Malley winked and made me blush. The plump fish in the pond had chiffon fins, and some were bulbous, asymmetrical like homegrown tomatoes. Of course, the French call them les poissons rouge, red fish; plump pulsing hearts navigating ponds and waterfalls. But to Americans, they must be gold. 'Thar's gold in them thar hills.' Pine trees line the lane. A cloudless sky. I tell myself, 'I am the universe,' then park the car at the pop-up testing site. A volunteer in scrubs and gloves, clipboard, a mask and shield, asks me for my ID. I'm ushered in, appointment checked, then sat till called. Nurse asks my name and DOB, instructs me to tilt back my head and breathe then probes my right nostril. The sterile stick is odorless. Nothing foreign's ever been that deep except for saltwater, and yes, I guess some viruses. Her cotton bud's encroached a sacred place where memories are made. What past might it erase? I choke back a silent scream as I remember his biggest fear. He used to volunteer at Sheppard Pratt and said he saw patients walk themselves in to electroshock therapy then get wheeled out, covered in drool. Perhaps he mixed it up with Kesey's Cuckoo's Nest, but either way,

it's what he dreads. I can't have him committed, declared unfit to take care of himself, despite the fact he can't. On the way home, I exit the interstate, content to drive these roads I used to roam. Red light at Falls and Cold Spring Avenue. I've been so many versions of me here: age 10, off to art camp, my mom still has the ceramic seaweed tile I made; 16 to meet a friend downtown for a blind double date with college guys, we lied about our age; then 21 in my Mustang convertible when someone yelled 'Nice bald spot' from behind; or on the way to my 30th birthday surprise—I bawled that they pulled it off; or 32, to sign divorce papers before the move to France. Particles of me have sprinkled like road salt then washed away for forty years.

Baltimore

For Linda Alberta Batyi 1906-1982

It's 1981. I'm in the back
of Nana's friend Camille's green Chevrolet
as she takes Nana—who can't drive—to the bank.
A muscular right arm reaching across
the bench seat as she steers with her left hand,
Miss Camille looks at me in the rearview
and brags that in the 1960s, my Nana
informed on members of the KKK.
She states that Nana joined for a few weeks
then took the names to the authorities.

At seven, I understood Camille was proud;
she felt her friend had stood up for her. My mom
tells me it can't be true, she would've known,
but when I check if Nana's bank was near
where Poppy worked, she says 'That's right,' then adds,
reflectively, 'I'm sure there's lots of things
my mother did I never knew about.'

To the Activists

I see you on TV, bemasked, with megaphone.
My meerkat ovaries perk up. I mishear 'streets'
as 'sheets.' You want my body there. I mute a moan.
Your genius deconstructs the media, deletes
old norms, deprograms centuries of brainwashing.
My genius is more intimate. I yearn
to give you this. To bolster you. Do what I can.
Till now, I never understood the groupie thing.

We move so deep, you skim flecked strands of DNA,
so high, you scissor Neowise's tails. Immense
yet microscopic. After, I'm spent while you go slay.
But I can't do you all. Instead, I'll broadcast, blare
the amplifying energy. Onstage, you sense
a prick like a flea bite, a pulse like a sun flare.

Suburban Quarantine

Gunshots go off near the basement room
in Baltimore where I'm in quarantine.
We're in the sticks, so I assume,
it's hunters and not cops
shooting at innocents.
They're going off nonstop.
At least 30 so far. At every half
a second or two seconds or five.
Up to 50 bullets now.
The dogs don't seem upset.
It fades. The shooter is on the move.

They're closer now. If I had a drone,
I'd see the hell is going on.
They're popcorn on the stove.
80...100.
It's multiple gunshots at once, not an echo,
from more than one type of firearm.
Who needs to shoot a gun?
Okay, it's done. A minute's pause.
Oh, one more bang.
And stopped.

Water flows through the pipes in the ceiling above.

Dog's nails tap hardwood.

My keyboard pattering these words.

Tinnitus rings both ears.

The computer fan whirrs.

I need to call my dad.

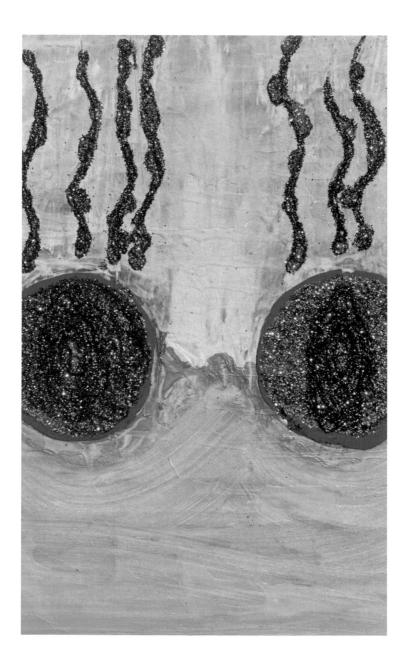

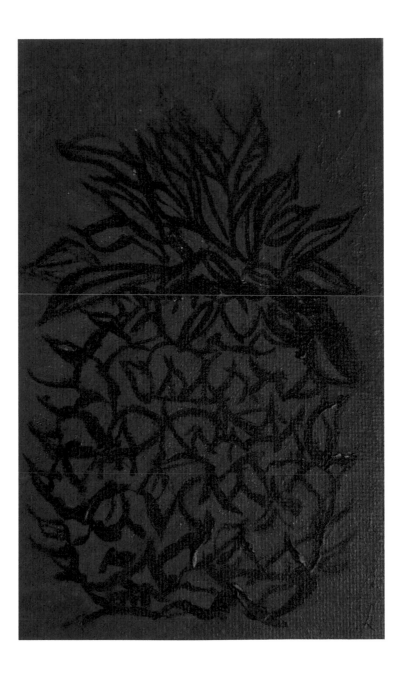

Dear Dad,

Mom says she's jealous that you're getting a book, she's not.
I get her point. She raised us on her own.
(I never knew you growing up.
Sometimes I'd walk past homeless men in Fells and ask if they were you.)
She doesn't know that not having to write
about her is the greatest compliment. It means that she's
the opposite of stress—what I escape to, not from.
I write the things my brain can't handle on its own.
I get them down on paper, see them on the page
then wrestle them into a form I can control, or I get overwhelmed.

My stepdads's never hidden his disdain for you,
for choosing drugs over your wife and kids.
He married Mom when we were eight and eleven and knew
you never tried to see us our whole lives
(until you sobered up and we grew up).
He didn't want you at my wedding at their house
but had to let you come. So as I pass him in the driveway,
roll down windows to say hello, and he asks if you're okay, tears come.
You have no clue how much it kills me, keeping you alive.

Flowers of Isolation

'Three years ago, we said he had nine lives,'
I tell the nurse who handed me his meds,
'but now, I think we're up to 25.'
She says, 'And they're the ones who go without
warning. I've seen it time and time again.
Something will come out of nowhere. They're gone
like that.' She snaps. 'No illness, suffering.'
Is that supposed to comfort me? That he'll
drop dead?

 'I can't think of anything to paint,'
he whines when I ask what art supplies he needs.
I've brought him lunch out on the porch, the sole
place I'm permitted to visit him. Next day,
I bring a bag of stuff I found on sale.
'I've never made a 12x12 before.'
He grabs Ivory Black and says, 'This shade
is for morons, oxymorons.' I watch him squeeze
a slug onto the canvas on his lap.
He whistles, 'Paint It Black' and paints it black
then props the canvas on the porch, tilted
so wet edges don't touch. The shadows of
the railing slats make black stripes on black.
 'It's hot enough outside, it'll dry in ten.'
He's allowed on the porch four times a day to smoke.

Other than that, he stays in his room, or cell,
as he calls it. Where would he go if he
could choose? The streets? Decades ago, before
sobriety, he lived in Highlandtown
beneath a highway billboard sign. He sings
The Drifters' tune but with his own new words:
'Under the billboard...on Haven Street.
Under the billboard...with Pollack Pete.'
They had a fire plug nearby and stole
a paddling pool—a chance to cool off from
hottest, humid city summertime.
He'd choose that life right now but there'd be no
one there to find him when he overdosed.

The new place sends me urgent messages.
His opioid replacement drug, Suboxone,
will be gone this week. 'Just give him aspirin,'
I say, 'and tell him it's his meds.' That's not
a fib. It's medicine. He wouldn't know
the difference. What he's addicted to
is the idea of never getting it.
Donna disagrees and says it curbs
his craving, keeps him calm. She might be right,
and I'm not qualified to make that call.

I'm writing his obituary while
he's still alive. He knows what day it is,
how long ago I picked him up, the names
of all the techs, that we're making a book.
The more he knows, the more he can forget:
his friend Lisa with a cane, his niece's names,
a three-month roommate at rehab on Lombard
Street, what he was in there for. He claims
he's isolated, bored, locked up. But if
I took him out to see his family
or friends, he'd be antsy to leave because
they'd talk to him of things he can't recall.

Wild Iris

She appears unannounced
in a bright purple dress and white mink stole,
rooted to her spot.

The wind picks up.
She's Marilyn in colour, holding down the front.
The sides ruffle around her shoulders.

Aged and wrinkled tissue paper
or a string of cicada shells
is a slouchily slung scarf around her neck.

With arms outstretched
she looks to the sky, absorbs the rain
in the wrinkles of her palms and face.

The Blue Lady

For Helen Roberta Borowy O'Dea (1916-1992)

*'By the way, Helen's telling me she's 23 on the other side, I said,
"Good for you, honey."'*

–transcript from Donna's family Zoom call with a
medium during lockdown

Bifocals magnify
skin that's already too big around her eyes
like a sweater not laid flat but hung to dry,
sagging from the clothespin's bite.

Her hair, dyed
charcoal black over her natural white,
levitates from her scalp between the times
she touches up her roots and reapplies
Clairol 65.

Her lips are lined
too dark, which tends to emphasise
instead of hide
creases so deep they look incised
from years of smoking Ultra Lights
and years of lies.

Banned

The golden years. A summer day.
Sundress, linen blazer. I'm happy, divorced.
He's been sober 10 years. Cargo shorts
and a guayabera shirt. Curly grey hair. Big belly, big smile.
Before retirement, the strokes, relapse.
We're chowing on burritos in Fells Point,
across the square from Shakespeare Street.
We chat about the neighborhood, how he was banned
from Mary's Polish Haven, around the corner,
for stealing a gumball machine. In fact,
he is still barred from there; it's written on
their liquor licence, so even though
it's changed hands (and names) a dozen times
since teenaged Dad had taken the machine
('As soon as I woke up and saw it in my room,
I took it back'), Dad has been banned for life.
He tells me the real reason was because
the owner's daughter had a crush on him.
'Her mom called me the scourge of Fells Point.'

After lunch, we walk along the water—sun twice
as strong, reflecting off the harbour's skin—
to what is now called One-Eyed Mike's
(formerly Mary's Polish Haven).
Inside, our eyes adjust. Dark din of wood
has vacuumed up the light.
Bartender: 'Hey guys, what can I getcha?'
Me: 'Can I see your liquor licence?'
Bartender, suddenly very formal: 'Yes, of course.'
He thinks I'm with the liquor board
and gets the licence off the wall, hands it to me.
'You see that name, Tommy O'Dea?' I point
to Dad. 'That's him.' The barman breaks into a smile.
'No way. Can I buy you a shot?'
According to the licence, he should kick him out.
Dad: 'I don't drink anymore.'
'A coffee?' 'Now you're talking.' 'Do you know
the other guy on here?' 'He fell off a stool
at Grundy's bar,' Dad says. 'Never the same after that.'

Five years later, my ex-husband calls to say
their mutual local coffee shop banned Dad
when they discovered tiny baggies in
the bathroom after he'd been there.

The doctor tells me it's possible that from his strokes,
he's fried the impulse-control centre of his brain.
When he wants something, he needs it immediately,
whether it's drugs, coffee, hot dogs, ear drops.

He's like an infant—all id and nothing else.
I cling to that narrative and make it truth.
I won't believe he's fallen off the wagon without cause.
But it's possible that after retirement
from forty years of working on the docks
(between the prison sentences for theft
and 'rogue and vagabond'), he was simply bored.

When I reach out to the charity
(a twenty-minute walk from Shakespeare Street)
where he volunteered for almost twenty years
to see if they would like their logo in our book—for free—
I'm notified that he's been banned from there as well.
He lifted speakers, wine and beer from their storage room;
the next day brought back everything
except two beers. I laugh because his MO hasn't changed
from his old gumball stealing days.
If I include them in any way, they say,
he might construe it as an open door and saunter back,
act like he owns the place. New staff who don't know him
could take his unpredictability as something else.
The phrase 'boundary issues' is used.
The person at the charity who clarifies all this
is the same one who years ago told me
that when she got pulled over for drunk driving at 3am,
she called my dad because she knew he'd come
and safely take her home, no questions asked.

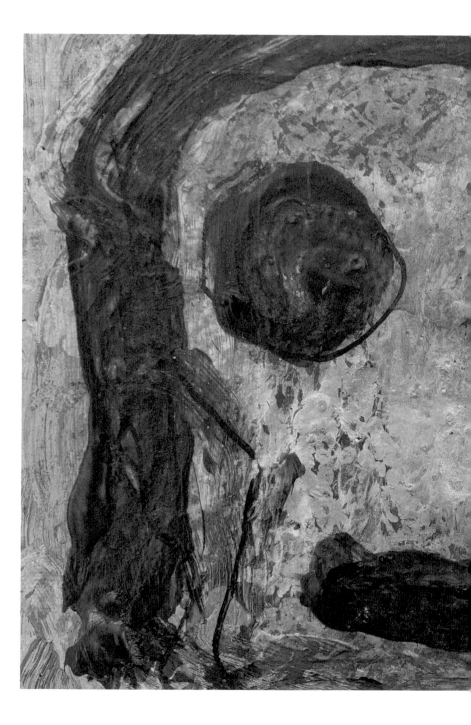

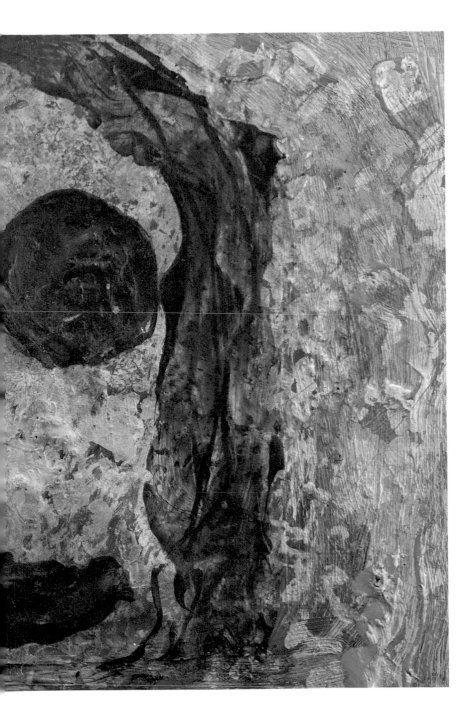

Dear Dad,

You say that you won't pay to stay in 'prison' anymore,
and sign yourself out of the assisted living place that I flew home
to take you to. You agree to transfer to long-term rehab downtown,
one mile from Shakespeare Street, that had been closed
to new clients since March because of the virus. They've reopened,
and they have space. It's free; a charity. Intakes on Monday.
They know you're coming in, and Sis will drop you off.
That's in a week. My little sister Jess, who loves you even though
she's not your child, lets us stay at her house
while she and her family vacation at the beach.
We watch a lot of British gangster shows, eat vegan food, you smoke
outside and drink Nespresso, even say hello to my stepdad when he comes
by to mow the grass. Donna joins us for carry out one night.
It feels normal. Jess and her family come home on your birthday.
We have pizza and cake. My nephews call you Dippy, the name
Eva gave you when she was three. They think that you're the silliest
adult they've ever met. After cake, you become restless;
I won't let you smoke around the kids. You leave with Sis.
We say goodbye as if it's any other night.

It's Ashlie's wedding this weekend; I'll need to help then leave
on Sunday for New York. The wedding is in Mom's front yard—
assigned seats distanced for each group, favours of hand-made masks.
(It's hard to recognise old friends.) You made Ashlie a card
and gave her cash. One year ago, when I was visiting, Ashlie and I
took you to lunch at Lexington. While we were still eating, you went
outside to smoke but never came back. We got security involved,
asked strangers if they'd seen you shuffling around, but no one had.

We walked then drove spirals of one-way streets for hours.
That evening, you showed up at the group home where you
were living at the time, told Donna you'd caught the bus, told me
you lost the door you'd exited and couldn't find your way back in,
told your housemate you got a hack. We'll never know.

The wedding shoes I bought blister my heels. My top,
a hand-me-down from Jess, is off-the-shoulder. Probably too young
for me. My stepdad asks where the rest of my skirt is.
Many guests who I don't know ask after you and wish you well.
They all love you. I get smashed before dinner is even served.
I'm basically the only one since I don't have to drive. I dance barefoot
under the marquis on grass my stepdad mowed two days before.

I take the train from Baltimore to Manhattan
and escalator to the street. I could do cartwheels down 6th Avenue;
* it is so bare. No yellow cabs precariously parked up, no bikes,*
no aggressive honking horns. The brazen bustle of New York
that intimidated me as an undergrad is gone. Eyes smile above masks.
People happy to see other people. I find one open pizza place
and grab a slice and Diet Coke to go. I eat them on the steps
of a closed bank, then take the train to Brooklyn where Chris
points out the slow return to normalcy: we hug, some tourists snap
Manhattan Bridge, most outdoor restaurants are full
(with every other table sat). But other things have changed:
'Don't pet my dog'; joggers stand aside on paths to let us pass;
the courts are empty, hoops have been removed.

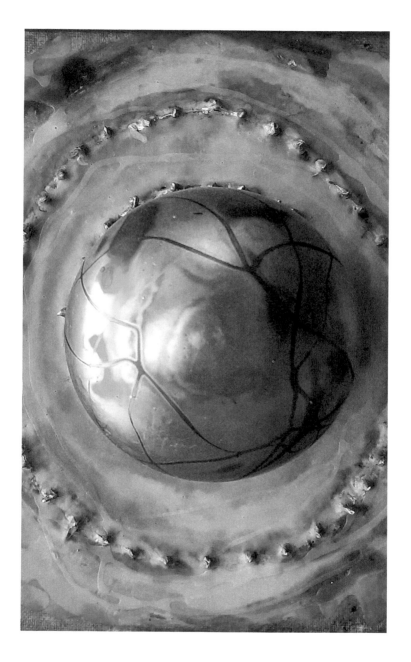

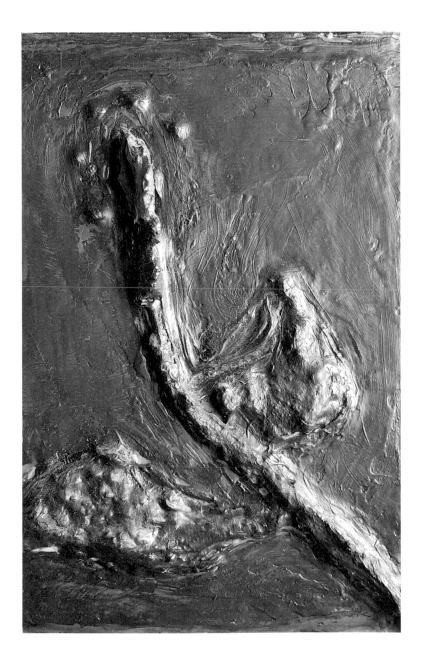

Substitution: Pandemic/Occupation

'Supermarkets Ration Supplies as Coronavirus Fear Empties Shelves'

–Wall Street Journal headline March 10, 2020

'Islanders became expert at producing substitutes: parsnip, barley and acorn provided the basis for ersatz coffee.'

–The British Channel Islands under German
Occupation, 1940-1945, Paul Sanders

'Coffee,' Dad yells. A metal bang on wood.
It's also been: 'Tobacco.' 'Porridge.' 'Lard.'
He barks for things his mind can't comprehend
that we don't have. I stir the foraged brew,
abubble on the fire, turn back. His chair
is bare. I find him standing in the yard,
sunlit and bordered with barbed wire. He snacks
on honeysuckle stems, his brain content.

Coffee's on every corner now. That scent—
a cedar-chocolate-charcoal-walnut-wax.
I take a sip of how he likes it, black,
it burns and tastes of granite, bleach and rust,
dried blood, a dentist's drill and tooth sawdust,
a wire fence, a metal bang on wood.

Of the Mouth and Lungs

On a cocktail napkin in the dining room,
he left a coffee ring. A wrinkled circle
on a paper square. I wish he'd forged
a diuturnal mark on book-matched oak
veneer. A stain I couldn't polish out
with Pledge, that branded thoughts of him each time
I cleared the plates and knives. Or a cigarette burn
on the upholstered chair, some permanent scar
to show that he'd been here. Instead, there's this
four-fold, translucent, paper souvenir
that will degrade and fade with air and time.
His cup's imprint tinted by overflow
and what might be the gray smudge of an ash.
Proof of his presence, his breath, that I can hold.

At the Sculpture Garden

The Bengal tiger sketch distracts
me from the empty bench. Beside the bench,
a stainless-steel sculpture that reflects
what's on the ground below, an aerial view
of plants and leaves. I'm standing in a wood
and looking down. No, now I'm in the tree.
My tiger body is suspended, dense,
pouring itself over the branch that splits
me in half, lets me observe the forest floor
without the parts of me to spoil the scene.
I can exist as what I perceive, dismiss
my body's ache or need. If I could live
inside the ceiling tiles, I'd be relieved.
The bench and tiger's gaze. Two fingers dig
between my ribs and feel the tissue strapped
across the bones. The left hand's like a claim.
The right's for pledges, swearing-in. The left
to left is awkward, inward, twisted, direct.

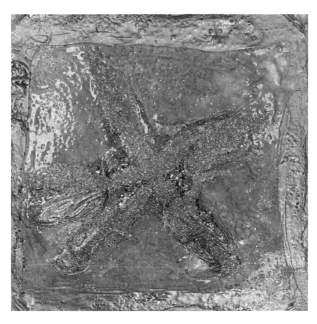

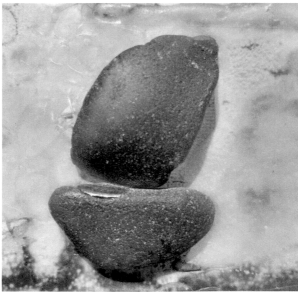

Dear Dad,

Monday morning, I wake up in DUMBO. Flying out today.
Are you at rehab yet? Will they take you? Will you stay?
Can I do this again? At ten am, the rehab emails me that you refused
their help and said you didn't know why you were there.
And wouldn't let them contact me or Sis to get you safe.
Do I give up? Or wait until I get the call?
I've spent the past five weeks keeping you safe.
Staring at four ventilation grates beneath the ceiling
of a converted factory, my brain is whirring like
a computer processor that keeps trying to load. It can't quite
get there. Sometimes when my students write in-class essays,
my brain will surge from feeling all their brains at work.
This feeling is akin but not euphoria. Maybe I can make it that.
Feel lightness you are free. That's what you want.
And if it kills you, at least you'll die happy.

Chris books me a ride to Prospect Park to see Mel and Twy before I fly
to the UK. Mel's dad—eighty, high risk—stays inside. I play catch
with your grand-god-daughter in their Brooklyn garden.
They send you lots of love; there's nothing else to do. We ride to JFK.
Once I'm through security, Sis texts that you're at the ER.
Black eye, scraped up, and waiting for a brain x-ray. I call.
They say you're there, but I can't reach your nurse.
I message friends and family to get in touch before I board the plane.
An airplane film while eating plastic-tinged lasagna from a tray
allows me to forget about you for a couple hours
(not really, though, you occupy the edges, like migraine
disco lights in my peripheral vision). I chew

two melatonin gummies. When they don't work, I pop two Sominex.
Eye mask above my COVID mask, I adjust to a Gollum-like contortion
that my spine detests—head curled into the seat back, hip tucked
in the fold, knees bent on the empty seat beside me.
I recite poems I've memorized—'We Real Cool,' 'Sonnet 55',
and 'Mending Wall' to lull my brain to sleep.

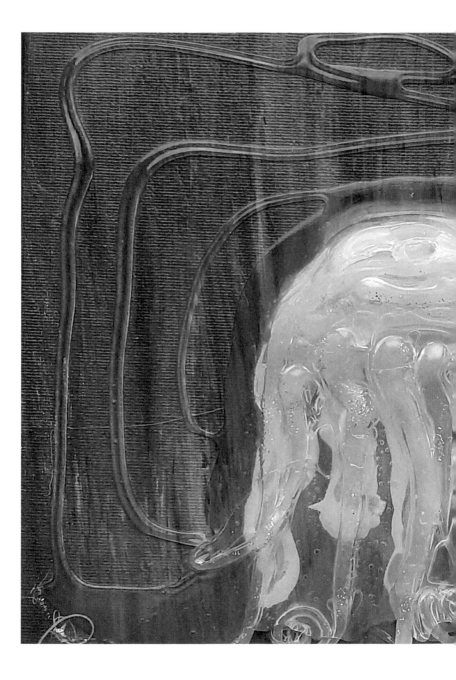

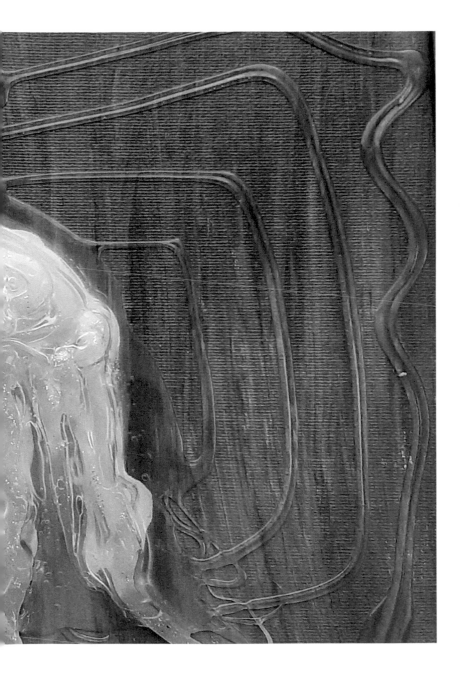

Reactions Speak Louder

'Stop thief!' I turned, as a poorly made up, permed,
misbuttoned woman hustled my way. I grabbed

her bag, and we played at tug of war until
the manager came out, so I don't have

to wonder anymore what I would do
if that happened to me. Sometimes I question how

I would react if someone flashed me
on the street—would I shriek and run? Avert

my eyes? Or say, 'Nice socks,' not missing a beat?
I may never know. When the bus sped off the road

and towards the ditch, we both stood up and clutched
seatbacks to brace ourselves and watched the scene

unfold. Passive. Serene. And when he dies,
what will I do? When I look at his work

I sometimes hold my notebook open, bid
the unlined pages to absorb the things

I want to say so I don't have to think
or write a single insufficient word.

But other times, I play at tug of war.

Photograph of a Woman Looking at His Jellyfish

He must've taken it from the hip.
A quick click. She didn't see him standing there.
The canvas is out of focus. In focus,
in black and white, the back of a woman stood
between the piece and him. Her hair I guess
is brown, hangs loose around her shoulder blades,
some tucked beneath a maybe blue canvas strap.
A few dead strands swirl down her sweater, past
her branded leather belt and baggy jeans,
and float to the golden, over-lacquered floor,
where later an unseen janitor collects
them with the dust and lint from other guests.
She's reaching out with her left hand; her thumb
and index finger are extended to touch
the still-wet-looking glue or yank the frame
right off the wall. A quarter of her face
exposed, lips just parted, she breathes it in.
The scene is more unfocused than normal, details
that aren't there aren't even there. The orange
and yellow jellyfish glow through greyscale,
the blurry shot, their background circumstance,
and Dad's abstraction. They sting the woman's cheek.

Recrudescence

Unbubbly water gurgles down the bathtub drain.
I stay. My body loses buoyancy in planes
as gravity returns to cross-sections of me.
I'm heavier above.

> After the surgery, as I came off
> the morphine drip, the pain resurfaced in
> the tiniest of increments: an old
> knee injury, eye throb, a kink in my
> left shoulder blade. Each one told me I had
> been painless once but didn't know it till
> the pain returned.

> Composer John Cage enters the anechoic lab
> with a windmill quest: silence.
> At first, Cage is fooled
> and hears the nothing from outside. He holds
> his breath, which makes the gaps
> that were collapsed
> before inflate and force tissue and bone
> to rearrange and creak. Then there's his heart
> and bloodrush noise between the beats.
> For all his listening,
> you think he would've known.

Does Dad actually enjoy his highs on heroin
or is it just that once he comes around,
he is nostalgic for the painlessness?

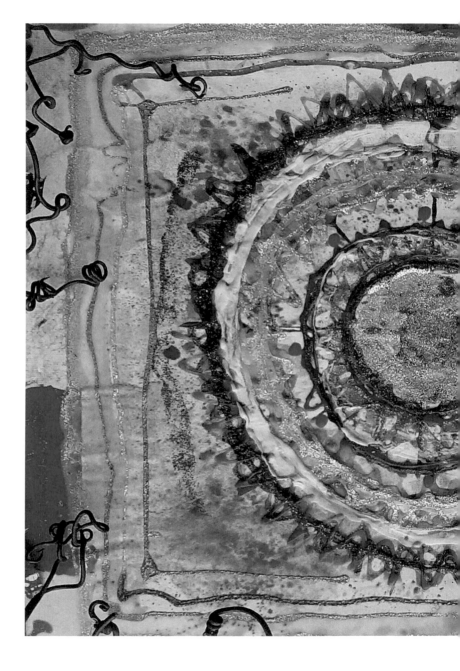

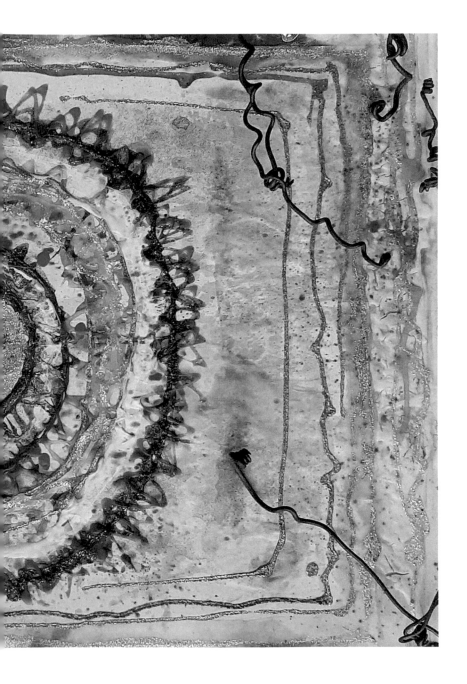

Dear Dad,

The hospital released you to a halfway house. They're nice, cook food.
The other residents talk your ear off, you say,
but it's better than the last place—no one spoke at all.
You lost $9000 on your one day out and 'hate to ask' if it was me.
Then don't. I let it go. You ask again next time I call. You ask Donna.
I call your bank. You blew it all in six hours or got swindled
when you were high. Bank checks, cash point withdraws and charges
plus non-network fees. Drug dealers must take cards these days.
Just swipe. You claim that someone stole your art supplies. I message Sis.
They're at her house. I don't ask her to drop them off.
The stealing accusations don't bother me. Not because I nicked your diary.
I've stolen this whole book from you, from Sis, from Mom, your friends,
my friends, our family, doctors, the sea, your art, the dead.

For a week, I try to call, but no one's ever there, or when they are,
you're not. You're at group. Or you just left. Are they covering for you?
Next week, the house supervisor says you've been in hospital.
You hurt your leg. You're walking with a cane. 'Has he been drinking?
Gotten drugs?' The only time you fall. I get you on the phone and ask
what happened. You say, 'My shoes,' then, 'Gotta go.' I call most nights
at 10pm my time, 5pm for you. You answer the land line, 'Dr. O'Dea,
Psychiatric Ward.' You say you're painting a beluga whale.
I send you long johns, a hoodie, wool cap and snacks.
A young guy answers, 'Which one is Tom?' I hear him ask.
'The old guy upstairs?' You do look old. You've aged ten years in two.
The hospitals and rehabs. Your inactivity. Your lack of purpose.
You will never be sober again. I know that. I'm just buying weeks

between ODs. But why? If there's no end in sight. To give
a few more years? Of living in homes that aren't your own?
I have let you down. What is your life? If I moved back
to Baltimore, I'd live with you. Your life would be my life.
I'd give up my marriage, the UK. Who knows if it would work?
That you'd stay sober or alive? Who's to say that I would not
get drunk and high with you? That my art is more
important than yours? That I should be alive instead of you? That I
should get a life? Four friends' parents have died since Lockdown One.
While I'm getting ready for Halloween, Donna messages:
'He and two others were caught using. Tommy couldn't walk.'
An ambulance drives you to the hospital for an OD,
but you grab a taxi back to the halfway house. The manager tells me—
as I cut out eyeholes in my Jack-O-Lantern costume—
'He's in my office nodding on a chair.' They say that they can't house
you anymore. Administrative discharge. I try to find someone to help
for a couple days until we can find you somewhere safe, but then
I get the call that you're in hospital again for an OD. Two in one day.
I'm unrecognisable beneath my homemade mask.

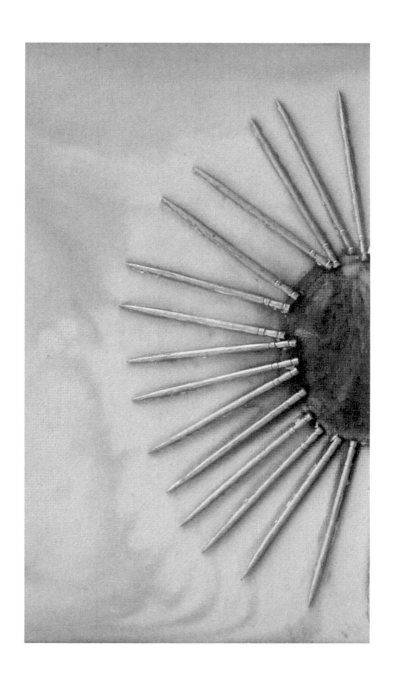

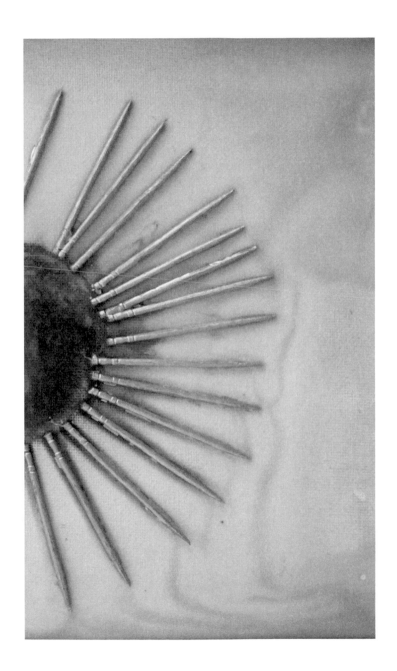

Our Neighbour Put Summer out with the Trash

The beach chair straddles the black garbage bag
that's bursting from the lidless, rusted bin.
It's a squat chair, the kind where your seat's in the sand,
and you inevitably end up getting soaked
from choosing a spot too close to cool your feet.

Frayed nylon sprays neon strings—
green, orange, pink, and yellow—
onto the otherwise glassphalt landscape
of the quiet, drizzled, autumn street.

Echocardiogram

I'm topless on the padded table in the hospital,
my back to the sonographer, my face towards the screen.
The gel-coated wand gives me goose bumps.
Nipples harden. In front of me, black screen at first and swish.
Like breathing with a SCUBA tank, the sound
both drowns out and amplifies all background noise.
The black changes to masses of grey dots
like when I jump into a swimming pool
and only see the bubbles that I've made until they clear.
Then there it is. My heart pumping on its own.
One grinchy hand clapping, sarcastically.
Well done, you. You've lived another day.
She moves the wand to show some Venus fly trap jaws
with ragged edges, chomping blood.
Then the pulmonic valve—a bulging, wrinkly,
blinking robot vulture eye—organically mechanical.
Its view is something I will never see.
At last, in the second chamber, some joy:
two kids at pattycake with nowhere else to go,
playing their uninterrupted game on a loop
until I die. This is the closest I will ever get
to an obstetric ultrasound.
This caged heart is mine and never leaving me.

Red Pineapple

Image of me: disheveled diadem
with bristly bracts that look like
feather fluff or praying palms.

Sharp strokes announce nuance—
a message in monochrome.

Fine flecks of gold glue
shine through where ruby red
has worn away. A hint at heresy.

Green Island

At 60 paces long and half as wide,
Green Island is a ship. I dip my head
over cliff's edge, recline on cabbage shrubs.
A masthead upside down, the sky's my sea.

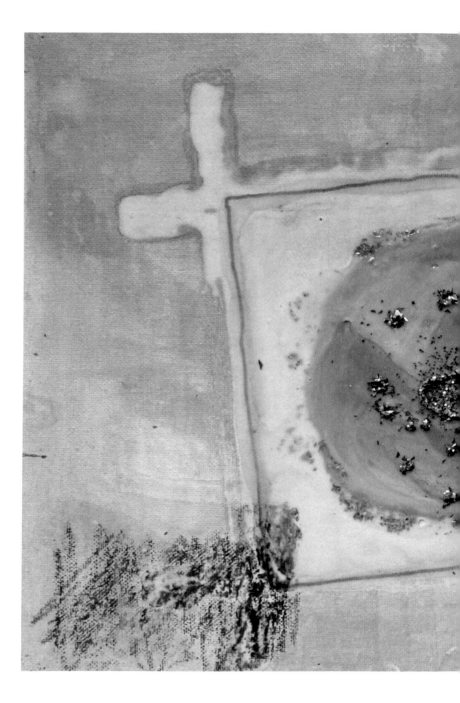

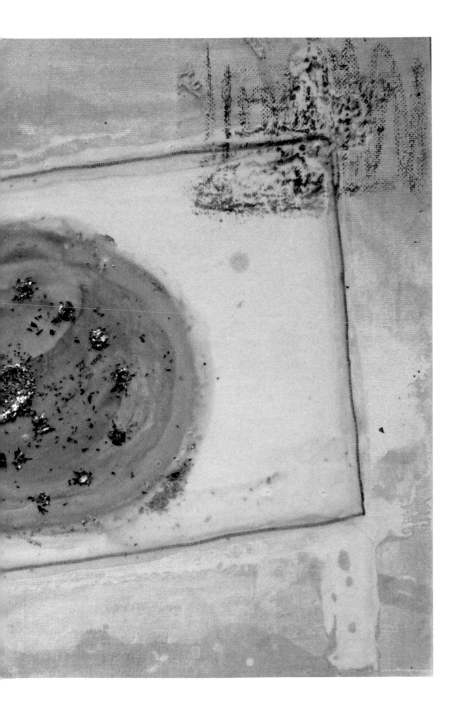

Dear Dad,

*I have to isolate because I'm first contact of someone positive
for COVID-19. My husband moves out so he can go to work.
You call Donna from your bed, 'Tell Traci I'm in room 928'.
I speak to your doctor, report your history. They question you
while I'm on the phone: the date, day of the week,
the president. 'Have you had any hallucinations?'
'I wish,' you say. I don't remind you of the story we were told.
I was just born, and Sis was three, and you were high on PCP.
You thought that Sis's crib was full of Orcs and threw a brick at them.
The reason Mom left you and why she hates Tolkien.*

*I get an email from the head of geriatrics that she wants to break
the cycle of 'being hospitalized, discharged to rehab, group home,
drug use, then back to the hospital' and help you to 'a better path.'
I'm encouraged, for once. I talk to you a couple times each day
while I'm isolating, about the first female vice president, your art,
our book, what's on TV. Sunday, I call; it's busy twice.
Later, a nurse picks up. She laughs, 'He was discharged.'
'What do you mean? No one called us. He wasn't safe to be discharged.'
'A rehab in Druid Hill. The social worker organised it.'
She wasn't in the loop and you slipped through a weekend crack.
'But he wasn't supposed to go back to rehab. I don't understand.
Where is he?' 'I don't know. I'll have someone call you back.'
'I'm in the UK.' 'Oh, you're in the UK?' (laughs) This isn't funny.
'Please have her email me. I need to know where he is.'
'I'll see if I can find her.' I message Donna. She hasn't heard a thing.*

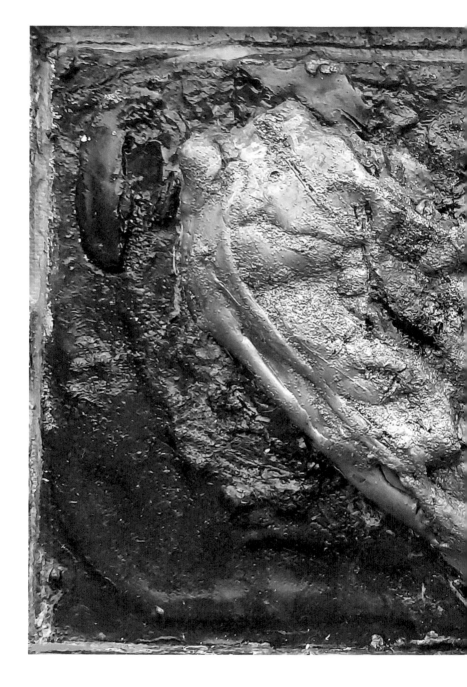

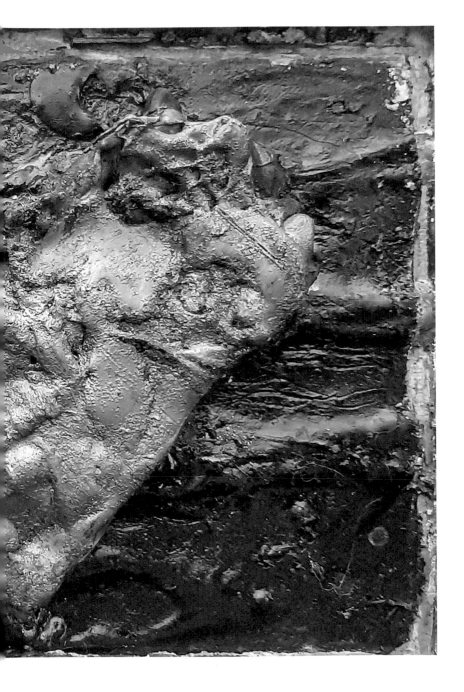

Self-Isolation

'Whilst isolating you must not leave your home or accommodation.'

'Isolation guidance,'

-gov.je

Our bedroom window's not a window seat,
well, not supposed to be a window seat,
but I'm straddling the oversized sill, one foot
holding the sash open to salty night air,
the other firmly planted on the linen chest.
This doesn't count as being outside, right?

A passing bus runs over seaweed pods
that have washed up. They pop like firewood.
I'd love to feel them burst between my toes.
Across the road, the black waves flicker from
street lamps and fairy lights along the wall.

Dog walkers three floors down don't notice me,
but one woman looks up then triple takes,
like she's apprehensive I might fall or jump.
One time, I did lean out a little bit
too far when my ash hadn't snuffed out.
I poured a splash of wine to douse the spark.

My husband's hotel room has the same view,
just farther down the street. The south wall of
the building's visible from where I perch.
His reading lamp shines through closed orange drapes
and adds an ember to the blazing sea.

Passenger Side

My husband drives the rental
to the testing site. We're both
in masks, the radio
is muted. So are we.

Cheek resting against the door,
with the window open, forehead
in the path of salty air,
I close my eyes.

At a stoplight, I squint my right
eye open and look into
the side view mirror. I see
myself asleep

with eyelids lying closed.
The left side of my face appears
serene, complete, but I
can't look for long.

I keep having to check back—
look into my open eyes
to confirm that I am, in fact,
awake and alive.

Bones

The sloped, pine-needled railroad trail ascends
from St Aubin to Corbière. At the top,
near the coast, the trees grow taller, farther apart.
Beneath one rough-barked fir, the path rejects
the petrified skeleton of a prehistoric cat.
Its black, gnarled bones unhurriedly emerge
from dirt, reveal themselves to passersby.
Ten years ago, after the surgery,
my body refused internal sutures, spat
them out of otherwise unblemished skin.
My fingertips would feel the polyester tips
poke through then pluck and flick the filaments.
I don't excavate the bones. I leave them be.
This island is a well-known Ice Age site.
Back down, a hedgehog pearls in front of me
with a flesh-gone rodent carcass in its mouth.
My husband knows to bestow my skeleton
to science. I want it in a classroom. Dressed
in a Santa's hat, sometimes, a rainbow lei.
Or with a cigarette, if that's allowed.
When dead, I want to be a part of life:
the school-aged crush, a failing grade, the stains
of puberty. I'll grin at them, instruct
it could be worse or that death's not so bad.

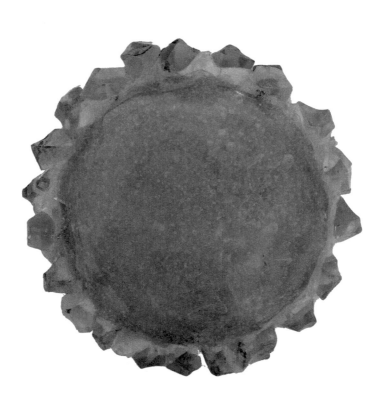

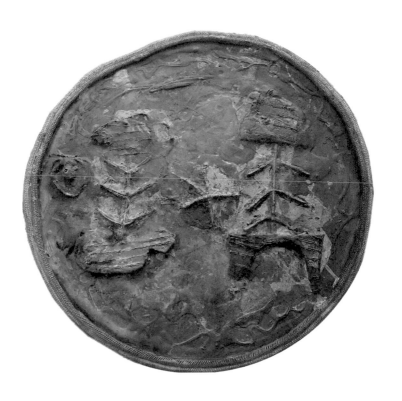

Dear Dad,

You're in a different room in a different hospital.
The team sets up a new assisted living home, privately run.
I tell the owner everything. How you will try to escape.
Or get street drugs. How you will fall. She assures us she can handle it.
Sis volunteers to take you there. She drops you off
and calls me right away to ask if I can get you out of it.
She hates the fact no one will love you there.
When there's an issue with the bill, we say that you can't pay.
Sis picks you up to live with her until we find somewhere
that gets your quirkiness (and crankiness) but keeps you safe.
The night before Christmas Eve with Bobby's kids and family,
we dine out in a restaurant while we still can. I get champagne
and then a string of texts from Sis: 'He's going to the ER'
then pictures start to load of you, face down in a pool of blood.
Half on, half off a mustard-coloured rug I gave to her.
'He's dead,' is my first thought. Before more photos appear,
I hand the phone across the table and ask Bobby to delete.
He texts her to ask if you're alive, breathing.
'He's going to Hopkins,' she writes. I message back
to ask if she's okay. She's not. She came downstairs, and there you were.
I want to know why she sent me those photos, why
she needed me to see, then realise that it's the same as me
writing this down. She needs proof to process it.
'Look what I dealt with today; here is my pain.'
I need others to feel it, too, to make it real,
to make the pain less mine. If I give some of it away, then I have less of it.
When you wake up, you don't remember anything.

Acknowledgments

The publication of this book is supported by a Seed Funding Grant from ArtHouse Jersey.

Poems in this manuscript have appeared, in some form, in the following places:

ArtHouse Jersey Presents
BBC Radio Jersey
BBC Upload
Jersey Arts Centre
The Jersey Evening Post
Jersey Festival of Words Podcast
Jersey Library
Liberation 75 Writing Challenge
Potion
Room of One's Own

Paintings are from the private collections of the following individuals:

Tami Elizabeth Bentz
Donna Del Prete
Tommy O'Dea
Traci O'Dea
Maeve Banks Reichert
Andrea Sine Yepsen